# HOROSCOPE

# HOROSCOPE

**HENRY MILLER**
LÉON-PAUL
FARGUE
ELIE FAURE
WILLIAM SAROYAN

PHOTOGRAPHS BY
RUDY BURCKHARDT

**TURTLE POINT PRESS**

© Turtle Point Press

*Horoscope* by Léon-Paul Fargue,
translated by Jeanine Herman
*Personalism* by Elie Faure,
translated by Anna Moschovakis

Photograph page 5: anonymous photographer, mid-1930s,
courtesy Gary Edwards, Washington, D.C.

All other photography: © Rudy Burckhardt,
courtesy Tibor de Nagy Gallery, New York

Design and Composition: Melissa Ehn
at Wilsted & Taylor Publishing Services

ISBN 1-885983-18-2
Library of Congress Number 96-060612

# CONTENTS

**MORE COSMIC MOMENTS**                            1
*Henry Miller*

**HOROSCOPE**                                     19
*Léon-Paul Fargue*

**PERSONALISM**                                   27
*Elie Faure*

**RESURRECTION OF A LIFE**                        53
*William Saroyan*

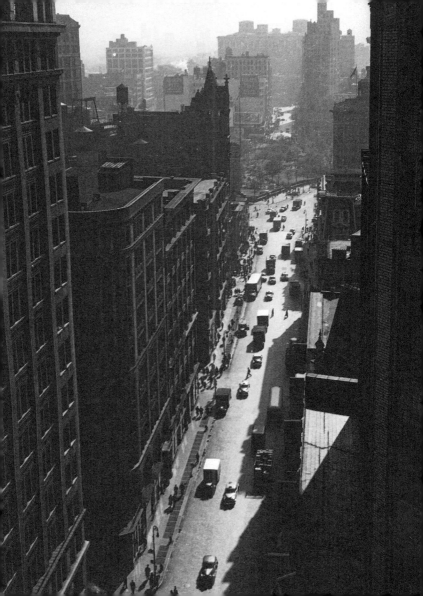

# More Cosmic Moments

It happens that I have met and talked with Will Slotnikoff. In New York, to be precise. And in a way that was a cosmic moment. Because somehow I feel that when you meet a man who has just begun to live a new life you carry away from such an encounter a living germ of the plasm of destiny and that this germ grows without your being aware of it and blooms one day in a supernatural guise.

Today, two years or so after our meeting in New York, I open Will Slotnikoff's letter and to my amazement there drops out on the table a translation of Léon-Paul Fargue's <u>Horoscope</u>. Nothing could be more astounding to me than to see on my breakfast table Will Slotnikoff's translation of this little essay. <u>Horoscope</u> via New York: absurd, incongruous, touching and nostalgic. Even more touching and nostalgic is to read about the bottle of Pernod.

Things are coming to a strange pass. Two years ago Will was a sculptor; he was also neurotic. I remember the evenings he spent at the 42nd Street Library, trying to forget that he would have to look for a job the next day. A factual-minded person might infer that it was the books which undermined Will. To be strictly accurate,

everything was undermining him. He had just joined the Philharmonic Society for Sulphurous Baths. First your hair falls out, then your teeth; your bones get mushy and the glue drops out of the hinges of your joints. Everything is ominous because everything points towards disintegration. Will went through a complete disintegration.

It was about this time that Bill Saroyan began to write me letters from San Francisco. He was just going through a resurrection, having taken a taxi to laughter and unending life. I tried to explain what Bill was going through to one of the editors of the Nouvelle Revue Française one day. He couldn't fit it into the cultural pattern. Then, just a few days later, I met a successful American author at the Dingo Bar, which was in the throes of rigor mortis, and I learned to my amazement that Saroyan was all ''cleaned up,'' as he said, and ready for the scrap heap. The next day I met a French poetess and she showed me the complete works of Léon-Paul Fargue.

Everything happens—this is my conclusion, at any rate—on sliding platforms. The man who receives this little accretion of ''Cosmic Moments'' may be living in Tel Aviv and just about to slit his throat from ennui. When he reads about the bottle of Pernod he may change his

mind. We may learn that he has been boning up on Thomas Aquinas in order to corroborate a theory of law which he cooked up all by himself. But in any case the bottle of Pernod focusses things. It gives you a picture of Anne Miller's restaurant, the 6th Avenue ''L'' and the ovarian world of our capitalistic culture. It does not explain <u>why</u> Utrillo painted green shutters, but it leaves you to imagine why.

And this reminds me of a cosmic moment which I experienced standing in front of a slot machine on the Lorimer Street elevated station of the Broadway-Canarsie Elevated Line, Brooklyn, some ten or twelve years ago. I had just come from a matinee at the Gayety Burlesque Theatre. It was a very poor show, but somehow it seemed to put me in a good mood. It was so very bad, the show, that my mind had begun to turn to things completely unrelated to burlesque, that is, <u>to</u> <u>sex</u>. If I remember rightly, the switch occurred just at that moment when Margie Pennetti was standing on the runway exposing her magnificent backside to the audience. She was standing directly above me, in a pair of white tights, full length white tights. Her performance was localized in the backside—there was nothing else to the performance. I looked up into the dirty white crotch of her tights and I went blank. That

is to say, I was completely carried away by my thoughts. There must have been something perfect, something totalitarian, about her ass. It left the imagination free to soar. From then on, at any rate, I was no longer in the theatre. I was everywhere at once, inside the dirty white crotch, of course.

I always remember Margie Pennetti—her big, beautiful, really magnificent white ass. It seemed to comprise the whole meaning of sex and left you free for other things, other thoughts. More burlesque stars have a way of setting you to thinking about sex. They never <u>give</u> you sex. Margie, on the other hand, always behaved as if the show were sex and nothing but. And this sex which she carried around with her was concentrated in her ass. She offered it regally. It was sex, and nothing more. It was a full dish, with soup, hors d'oeuvres, fish, roast pigeon, vegetables, cheese, dessert, wine, coffee, nuts and liqueur. You got your money's worth and when you had downed it you could dismiss it from your mind. You didn't begin to think of other cunts whom you would like to sleep with, or of the cunts you should have slept with and didn't. You didn't even think of Margie any more, or of her enormous white ass.

I was trying to explain this one night re-

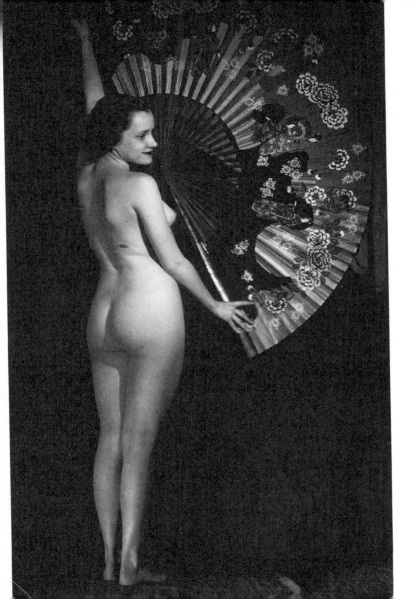

cently to a friend of mine; I don't think I made it quite clear. But I am very clear about what I felt, especially how I felt afterwards when I had left the theatre and was standing up there on the Broadway L station looking down at the little triangular park in front of the Gayety. I think of all this now because of the bottle of Pernod which Slotnikoff mentions. Then I knew nothing about Pernod. I went straight to the chewing gum machine and I extracted a slab of Wrigley's Peppermint Gum and I put it in my mouth and chewed it ferociously. I was ferociously gay and alive up there on the L station and I was just a little desperate for want of a pencil and paper. I had been living a sort of negative, destructive life in which each day I fought down the impulse to write. I was afraid to write because I knew in advance it would not come out right. But I thought about writing all day long. It was my sole obsession. And so I never wrote.

I used to write everything in my head. Not at a desk, to be sure, but riding in the subway trains, or walking the streets. My body was active, terribly active. I was always going some place, and of course never arriving anywhere. But I was changing trains frequently, climbing up and down stairs, standing in front of show windows, marching in and out of hotel lobbies,

sometimes standing in the penny arcades with an ear phone listening to a cantatrice warbling an operatic air, or else bending down and looking at a pornographic still. Click, click, and the shutter flops down. A new slide, a new bit of lace, a bare leg, maybe a teat falling out. A man with a straw hat stands in his underwear gazing at a young woman reclining on the grass. Nothing is terminated. It is a still <u>about</u> sex, but there is no sex in it. However, I don't complain. One has no right to complain if he doesn't get a good fuck on the grass for a penny.

Still, all that seems tied up very definitely with New York in my mind. The constant fruitless hither and thither movement, the desire to be doing the other thing all the time. Always yesterday, tomorrow, the day before, next week, next year. <u>Maybe this</u> . . . <u>maybe that</u>. But never THE thing. Never. Except, as I have tried to explain, for Margie Pennetti's white ass. That was real, satisfying, totalitarian. Sex on a platter and all you could eat. A bellyful, what! So that, leaving the theatre that afternoon, I was alone and beautifully mad standing there on the Lorimer Street L station. A desolate spot. Exactly the atmosphere of a bad dream, of a nightmare. Paper box factories, shoe factories, hardware stores, Jewish deli-

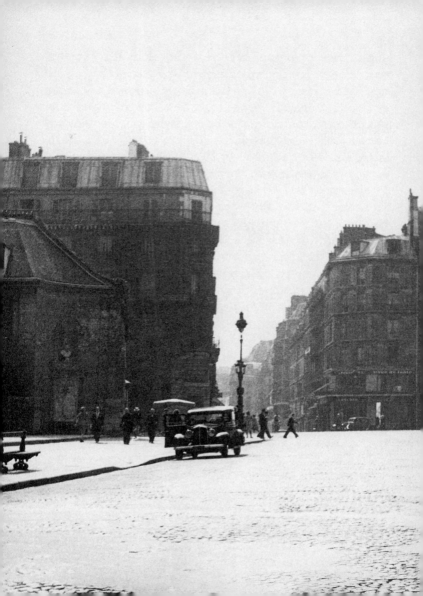

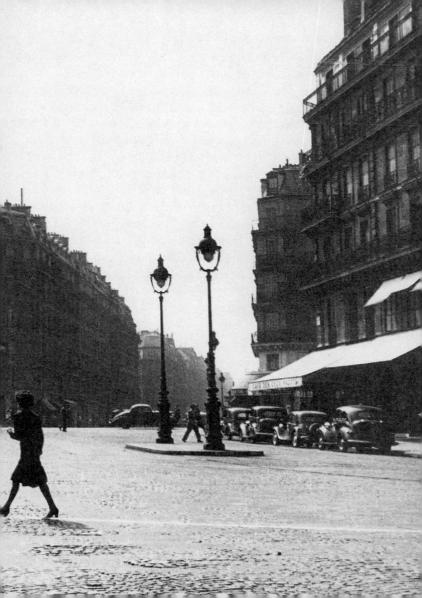

catessen stores. Never a bistrot, never a gay-colored awning. No Pernods, no _fines_, no Noilly-Cassis, no Chartreuse, no nothing. Chewing gum—from the slot machine. No handling charges. Just put a penny in the slot and out it comes, all wrapped up very carefully so as not to dry out ahead of time. A thin base of chicle sprinkled with whatever flavor your heart desires. Sometimes money rolls out instead of gum. And always a little mirror that you look into as you push the plunger. You see yourself in your most idiotic guise. Maybe your teeth will look a little whiter after you chew. You ought to shave. Sleep a little more. What time is it? You turn away and there are the gray clouds of Brooklyn, New York, rolling in from Canarsie, Hoboken, the swamps of Jersey, the Hackensack River. Everything is mucilaginous and opaque and greasy and hopeless. But the gum has a fine flavor. You forget while chewing, if you chew ferociously enough. And your teeth whiten.

And now, at this moment, today, there joins up with that cosmic moment another moment which I can only think of as growing out of that moment on the L station. This to-day when I open the pages of ''Europe'' and find, together with a translation of my little book, Aller Retour New York, an essay by Elie Faure called ''A propos du

personnalisme.'' I feel as though I were walk-
ing arm in arm with him, the master, the one
writer in all Europe for whom I have, and always
have had, a profound respect. It seems that we
came down from the Lorimer Street Station to-
gether, the master and I, and that we are tra-
versing the same wide open plain splashed with
sunlight, that we are eating champagne and
oysters as Melville recommends for the body,
that we are eating light, as Melville recom-
mended for the soul's nourishment. It is the
same day as it was then twelve years ago, though
everything has changed, myself included. C'est
le bel aujourd'hui! I am going out in a minute to
buy some cheese for my dessert. The roast veal is
warming up in the iron pot and the haricots verts
are also warming up. And there is a good bottle of
Bourgogne on the window sill and down below, in
the Villa Seurat, the alley cats are preening
themselves for the rain has stopped and the sun
is coming out strong. In the next issue of ''Eu-
rope'' M. Cassou, the editor, promises to pub-
lish my ''Universe of Death''—in French. It is
the most lively dead universe that has ever been
put in print. It is not me, however, but my dead
comfreres, Proust and Joyce. I have embalmed
them so that they will last another hundred
years or so. Just as I am embalming Margie Pen-

netti's white ass—and that bottle of Pernod which Will was carrying under the Sixth Avenue Elevated Station. The hearse is passing—I doff my hat . . .

''With more of me than ever before, <u>with all of myself</u>,'' says Will in his little essay . . . ''To be the moment with all of myself.'' It seems to me that this is what Goethe was talking about and St. Augustine and Proust—<u>and Whitman</u>! The Song of Myself is the song of the world, the tiny drop that makes the ocean. It seems to me that everything I pick up lately is only this theme and nothing more, that every time I underline a phrase I am underlining this phrase. Everything starts from this moment when you are more than ever before, when you are all of yourself and nothing but yourself. This is the moment when you are more than ever alone and yet more immediately related to the world than any other moment. You pass into an impersonal union with the world, into a state of acceptance.

If I thought of Margie Pennetti before and that moment up on the Lorimer Street L station it is only because, as with Proust, there were many moments in my life when I was there with my whole self and then only was I truly alive, without memory, without guilt, without regret or remorse. Totalitarian moments in which I had no

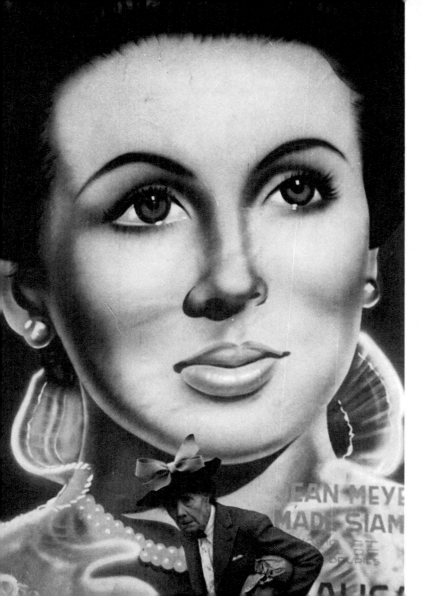

need of armies or navies, governments, taxes, libraries, museums, books, knowledge, etc. These moments stand out just like Margie Pennetti's white ass stood out in the brilliance of the spotlight. The world curves above your head like a beautiful white crotch and gives you the feeling of ALL. And then you move out of the spotlight and you are multiplicity again, but the light is still with you and everywhere your eye turns things travel back to you in broad beams full of wholeness. This is a holy feeling, no doubt, produced by wholeness. It explains the singleness and the multiplicity of things. It explains everything without recourse to explanation.

And one of the strangest things about such a moment, as I look back upon my life, is that it should occur in America. More particularly in New York. Still more particularly on the Lorimer Street L station. This is an enigma which I pass on to my friend, Bill Saroyan, the American who has written more about cosmic moments than any other man alive inhabiting that continent. I want Bill to explain something about cosmic moments for the benefit of the editors of the <u>Nouvelle Revue Française</u>. And then I want to ask Bill to pass it on to some friend in Timbuctoo or Mozambique who will in turn pass it on to some one

else and so around the world until the book is saturated with cosmic moments. In this way the bottle of Pernod will have served its purpose, and so too will Margie Pennetti's glorious white ass. For the world that is made up of cosmic moments is a world created just by such delicate little mementoes. It is a world made up of ever-lasting moments whose symbols, X-Y-Z, are capable of inexhaustible transliterations. In this world nothing needs to be preserved because all arrangements for perpetuation have already been made in advance. As you take your place in the world the bottle too takes its place in the world and the bottle lives on as you live on and just as you outgrow yourself the bottle too outgrows itself. The bottle of Pernod becomes all the bottles of Pernod that ever were or ever will be. It becomes the Holy Bottle on which Rabelais got drunk, the mysterious bottle which defies description.

And so, Brother Will, I stretch my mitt out across the ocean and I give you a sober hand-shake. I hope that during your more or less uncertain stay in America you will continue to drink from the bottle, that you will always see the shutters green as Utrillo made them, the baths as sulphurous as Fargue described them. And I hope that the Sixth Avenue ''L'' will re-

main what it always had been—a thing of horror and of beauty, so that forlorn poets staggering out of cosy restaurants will be reminded of simple things and long to communicate with the world.

Henry Miller
18 Villa Seurat
Paris (xiv)
April 23rd, 1937.

If you haven't seen my Cosmic Moments let me know & I will send you a copy.

# HOROSCOPE

### LÉON-PAUL FARGUE

I know my hour. Though I have not examined the point of the ecliptic that was at the horizon when I breached the nothingness, with a magnifying glass, compass, goniometer or incandescent light, I know and recognize myself like a good banknote. When I go to a restaurant, into the night or world, I consent, I go along, but deep down I'm skeptical. I know myself.

My sign is that of urchins, zebras of the sea, shellfish, barbed pterygoids, scaly groupers, spiny fish with suction-cups, faces so blue they seem close-shaven. I live in the company of seamen, jazz writers, astronomers, hypnotizers, psychologists, tobacconists and hotel clerks. These are my secret brothers, haunted by the same teeming of maternal stars. Freemasons of my moment, they live the same life, drink the

---

``Today, two years or so after our meeting in New York, I open Will Slotnikoff's letter and to my amazement there drops out on the table a translation of Léon-Paul Fargue's Horoscope. Nothing could be more astounding to me . . .''

same beer, love the same woman, die the same death. I have a number, a day, a birthstone, a climate, favorite dishes, pears for when I'm thirsty, comings and goings of predilection, and vices which I do not confuse. I know that I am supposed to pick my friends in Cancer or Scorpio, my mistresses in Virgo, Taurus or Capricorn. I get the sense it has all been prearranged, from the lighter of street lamps who threw old straw on me every evening when I went to lycée, to trains that arrive late, and ushers who wait for me like sentinels at the turning points of weeks and years. All censors, bus ticket inspectors, taxi drivers with sudden breakdowns, and bibliophilic concierges are my travelling companions, just as unexpected downpours, the streets one does not find, banana peels, and abrupt embraces, long desired but no longer hoped for, are gifts.

I am surrounded, marked, registered, pinpointed. I have a speedometer in my lungs, a scale in my eye, a calendar in my ear, a Michelin map beneath the soles of my feet; mirrors, atlases, sets of keys, chronometers over my whole body. When I get up, I clock in before starting life, like a good worker, but if I do overtime, I don't get paid extra. I have twelve thousand senses, quays of ideas, colonies of feelings, a memory of three million hectares. And I know a lot of other things besides.

Like the traveller in a train car pacing the corridor while the train glides into the countryside like a carpenter's plane, my destiny makes its way through me, and yet it submits to me. It obeys me. When it races off, I hold it back, when it falls asleep, I rouse it. It thinks it is stronger than me and taunts me,

choosing its moment, for example, the step between waking and sleep that one always trips over. That is generally when I see it, slightly affected, slightly aristocratic, its eye clouded and cosmic, brain-colored, restless like a typhoon, twitching, anxious, a sort of toy balloon Gargantua, neither entirely a dream nor entirely a threat, enormous and flaccid, so large it occupies my whole eye, sky and nothingness, as heavy as sleep, as elusive as a handful of water, a waterfall's presence, an ocean's hypocrisy.

And in the morning when I feel a bit childlike, covered in goosebumps and trembling with indecision, my destiny enters me like a hunger, the kind that suddenly breaks into your stomach, that treats you like a safe. I see it and I don't: it's like a shroud and a headache, its voice is perhaps mine, perhaps its own, a distant voice over a broken telephone giving me the advice of a grandmother and delinquent, which I listen to. I swim in it and it swims in me. Fish.

When I feel it has settled in me, when we are enmeshed like wrestlers who are allowed anything and take advantage of this to force navel into ear, when I descend into it and it descends into me, and, with the circular airs of an elastic sphere, it takes charge of my affairs, this star in Southern Pisces starts to lecture me so disdainfully that I blunder out of argumentativeness. Destiny is the hurricane in a bottle that ferments in the breastbone. A zodiac sign, the Sign, Yours, the one whose stray bullet you are on earth, is the ground swell that capsizes you.

Mine is titled. It has a coat of arms in the shape of a fish

trunk; it is astonishingly hirsute, spiky like the iron Virgin in Cologne. It is the color of an aquarium, full of itself like a country moon, yellow above ponds of blood. It exists more than me, eternal, established, just for those who have been tangents to it, like a recruitment office. Like those men who have noticed once or ten times, have perhaps even spoken once or ten times to some milkmaid or princess, some cat, some cousin or sister, and thought they had rights over her, my destiny assumes rights over me. All my life, then, will I have to let my blood settle, buy amethysts, write about amethysts, put pieces of amethyst beneath the legs of unsteady tables, float in diaphanousness, and show a predilection for brown? And, then, the spines of my books will be chestnut, my pupils bay, my socks bronze, my enemies chocolate, my friends tobacco, my mistresses golden, my maids café au lait. I will be the large dark native of auburn boulevards, the brunet in the hazelnut sweater, emerging only in the ashen hours of brownish-gray and earthy neighborhoods to frighten and harm sunburnt harlots. And be marooned, on top of it! All my life?

All my life, says the monster.

My uncle gave me a stone for a power hammer, a stone the color of an ice rink, a corundum, a pretty, astringent and monotone ring that long served as my companion. Upon further inquiry, it was not my uncle. This piece of alum, the color of semen and lettuce, had fallen on us from the sky on a Monday, like an aerolite. We tried, to no avail, to lose it; it was found again. And when it was found, it was lost again. How many times did I rage against this eye, against this dreamlike

scrap with its laboratory smell that no shoe sole could reduce to powder, against this nebulous speck. Nothing could be done, it was destiny!

All my life?

All my life, replies the Southern Sky.

When I stay in a hotel, I try to get number 11. I leave my house at eleven o'clock, I give eleven francs to the phantoms, I bet on eleven, I have eleven friends and eleven enemies, I count to eleven.

In the eleventh district, at the eleventh hour, in front of number 11 of the eleventh street starting from the Seine, the eleventh in a row of blondes murmurs to me and fawns, taking me for a bonze, in her voice of bronze:

Say, don juan, let me redden your dawns?

A hundred times I have wanted to be Aries, Cancer, Aquarius. But then it would be thirteen, platinum, daffodils, mild tobacco, chicken in wine sauce, the suburbs. Having given up all hope of being a free man, possessor of a hand without lines, of a sky without stars, as pointless on the surface of the planet as a breeze, a witty remark, I have often dreamed of another zodiac. Of a zodiac that would not oblige me to marry twice, to present myself as a radical emphysemic delegate in Trois-Sèvres, to clean my clothes in histogenol or contract laryngitis passing branch $ax(2)+bx+c$ of the Crédit Lyonnais. Quick, another algebra, less anticipated alopecia, women without predestination and new dreams under collapsible skies! A zodiac that would be a lemon press, a fascist, a private tutor, a black tulip, a tatterdemalion, a philharmonic so-

ciety for sulphurous baths of railroad capitalism. Enough celestial telegrams, military papers for solitary men, extra-stellar passports.

Happily, I've escaped this gathering of souls. There are no intellectual symptoms in my fingerprints, no filings of poetry on my envelopes, they will be sought in vain, I remain without past or future. I have no hollows anywhere. I want no shadow over the ground but the one cast by my wounded tenderness. I am not a number on a roulette wheel, and I turn as I please, always infinitely available. My destiny is each night's effort toward myself, it is the return to the heart with slow steps along cities enslaved to the bureaucracy of mystery. What does it matter if I'm born, dead, have a hundred years of hair, a predisposition for the merchant marines, a measure of argumentativeness, and faithful wives in other people's beds? What does it matter if I've made an advance reservation in this world, which I know having made it? I am of those who sow destiny, who have discovered the cloakroom before venturing into full life. I've arrived entirely naked, without cosmic tattoos. The gentle giant who annoys me when I still feel deboned by sleep is the universe I have created for myself, that keeps me warm in my dreams. If I die tomorrow, it will be from an attack of disobedience.

# PERSONALISM

## ELIE FAURE

*For José Bergamin*

**H**ere we stand today, the outcasts, rebels, and resisters, the penniless and the knowledge-seekers, non-conformists and atheists, the lawless and the churchless; we who have abandoned the warmth of our family hearths to enter into the unknown, with drunkenness or despair. Here we stand, in the face of a coming world, just as you found yourselves some two thousand years ago facing the birth of a new era. We have had enough discourse, clarification, and transcendence. In matters of the mind, we are primitives, simpletons. We accept the epithet with pride; we accept your mistrust, we will even accept your condescension, if you will accord us that. Moreover, it doesn't matter to us that your confessional humility has led to the self-satisfied secular and ecclesiastic writings of today.

---

``This to-day when I open the pages of ``Europe'' and find, together with a translation of my little book, Aller Retour New York, an essay by Elie Faure called ``A propos du personnalisme.'' I feel as though I were walking arm in arm with him . . .''

Perhaps *we* are the ones defending what little humanity survives in Christian culture, defending it against none other than yourselves, taking care that it does not lose itself completely in the circuitous meandering of untethered intelligence. Marcus Aurelius and Julian both possessed intelligence. They erred against instinct.

We are presented with the task of wanting to construct crude synthesis. Philosophical "truth," so easily attained at the end of a string of syllogisms, leaves us cold, because we have within ourselves, alive and profoundly rooted, the intuition of a world in genesis, in which scientific and social reality strive for reconciliation. Now you rally around Monism, after having fought against it; you rally around it temporarily, awaiting the new arguments some shrewd cleric will supply, allowing you to scorn it—just as you pretend to forget Transformism, which you first rejected in horror, then accepted, then quibbled with. You don't care to remember having silenced Galileo, but you can no longer deny that the earth turns. But to us, Monism is more than a metaphysical juggling ball; it is a cosmic and biological reality around which we intend to construct a system in which a co-mingling of blood and spirit will circulate among men. In spite of, and perhaps even in opposition to the excesses and absurdities of his followers, we accept in Freud, as we have accepted in Spinoza, in Newton, in Lamarck, in Claude Bernard, and in two or three others, a new father of a church whose teachings introduce, little by little, the torment of our minds into the calm of our hearts. What interests us now is not the so-called reve-

lations passed down from an external power to fertilize our activity; but rather the sensations, the desires, the sufferings which our glandular secretions add to the controlling, cortical reflexes, as we digest the confluence of voices, forms, matter, breath, and appearances, of catastrophes and insinuations of the universe, continually being deposited in all of our organs. That is where for us all the unfathomable mystery, all the poetry, and God himself can be found.

We have had enough of the guardian of Metaphysics whom you claim to be preserving. Although we are becoming simple again—you use its simplicity to demonstrate a subtlety that we can no longer comprehend, Sophism is the final resource of dying societies, as simplicity is the primary spirit of emergent ones. You suggest organized philosophy as a cure for Man's hunger, while Man looks to organic life to appease and maintain this very hunger.

Never has a society been founded on the mere facts of consciousness. It begins with the instinct of the masses, of the crowd of simpletons; an instinct which, although formed in part by Intelligence, for the most part sees Intelligence as a super-structure, whose function it is to help it avoid blunders. We are aware that at the heart of Christian thought, like Classical thought—which you have had the merit and the diplomacy to amalgamate into Catholicism (although they collide when they descend into the profoundest depths of humanity)—there exists a powerful lever of spiritual, even intellectual conquest, which exerts a sense of submission superior to the necessity to think and reason, even when the foundations

of thought and reason remain questionable or false. But we claim—thanks to the accumulation in us of Christian and Classical thought, and certainly thanks to the repression into the secular of our instincts, which has revived and purified them—to have no more need of Christianity, or of Classicism, in order to find that lever and to consent to that submission. By renouncing eternal life, which you no longer mention, but maintain like a sword suspended by a thread over the heads of the poor; by suppressing our idea of punishment and reward beyond the grave, which we use, knowing that it has managed to insinuate its invisible presence, its lasting echo or sudden intrusion, into all that is noble or petty in us; by freeing ourselves of these notions, we are clearing a field far greater and more fertile than the one they cultivate, healthier for the activities of the mind and spirit. No doubt the field which we now sow has been nourished by all these ideas.

Do not be mistaken. We are giving birth to a new culture, and the social body is in pain. We don't deny that you should inject into this new culture that which should be borrowed from the old culture—the culture which the people had founded on their needs, and which you seized and submerged in a parasitic flood of ornamentation, like the images of the last cathedrals in which the rectitude and nudity of the buttresses, the *entablements*, the capitals and columns, is buried in the profusion of *bas-reliefs* and sculptures. Do not be mistaken. We will triumph over you, sooner or later; and if one day we construct statues in your likeness, it cannot be before you have already been beaten. For you have a battle ahead of

you; you may fight it, and you may curse it. Today, you are as closely tied to a dying Capitalism as you were yesterday to Feudalism, and as you will be tomorrow, if the revolution should miscarry, to all natural or supernatural oppression of the masses by the agents of power. You are tied to it like a convict to his chains, because you *can* rule only on the condition that there be uneducated multitudes who can neither criticize nor judge your transcendent ratiocination. So persist in your games, which relegate to the shadows and the contrived mystery of candlelight, a simplistic metaphysics of a sentimental Christianity, the themes of which were first given to your scribes by none other than the poor.

You cannot prevent your myths, which were and remain touchingly poetic, and which are even further from you than they are from us, from losing their place at the foundation of human society, except as a reminder of the symbols that once moved the multitudes. They can no longer believe in your myths except as symbols, not reality. They need new symbols, because they find themselves facing new realities.

You are, at this juncture, in full Protestantism—even though the Reformation (no doubt you remember), has now skated across the same economic terrain where the Nordic bourgeoisie founded the reign of Capital. Like them, you will run aground, or rather you will run *into* the social impasse at which point the people will be forced to break down the walls in order to enter. You are trying to tailor an old, shredded suit to fit athletic bodies for which it was not designed. You make endless alterations—but Beware! for the Church must not

vacillate, or else it is no longer the Church. You are, despite your address and diplomacy, *against* all of its dogmas. I do not take it upon myself to demonstrate this—and it would be useless anyway, since if you weren't against it, you would flee the discussion and hide behind your unwavering attachment to the aspects of the Church which were, in the beginning, the most intelligent and the most pure. The only ones among you who escape these criticisms are the humble priests, the humbly faithful—that is to say, the ones who, one day or another, without you, will reunite the *new* beliefs of the people after the people have won, the beliefs that will bring them new certitudes, new possibilities of action.

## II

What you call "culture" is the pedantic remainders of a literary caste affiliated with a dying bourgeoisie, whose interests it serves by dressing them in idealistic, patriotic and religious garb. This culture has become the enemy of the commoner, and people in general, precisely because it has, fundamentally, created itself, and because the evolution of its needs has already caused it to outgrow, to exceed, and thus to bury its own creation. The aspect of cultural *permanence*, which you claim to be defending, will not be recognized by the people until it has rediscovered its living roots, from which you distance yourselves more and more, beneath the great pile of branches, of leaves, of fruits, of all the artificial ornaments with which you have laden the tree of science, hoping to cor-

rupt the people and to bar them from the doors to a paradise they can just barely glimpse.

The great eras of culture, those which have produced the Parthenons, the pagodas, the mosques, and the cathedrals, are the blossoming of profound forces accumulated in the heart of the people by their hopes, by their sufferings, by their suppressed desires; culture as you conceive of it does nothing but facilitate, with the help of a few heroic geniuses, the passage of one set of outdated synthesis to a new set of synthesis in formation. But for my part, I have never found anyone but the very rare scholars and the very rare artists who are capable of grasping, in the procession of appearances, the power lines linking the concrete to the abstract, time to space, and the human soul to the universe. The zealots and the critics always travel to one side or the other. Must I tell you that in these dramatic times, people, with a searing intuition of their profound reality, take up the arms which have heretofore been designated to help them—both machines of creation and machines of destruction. It seems to me an incontestable fact that a Castilian peasant, a Catalan laborer or an Asturian miner is in general a more authentic member of civilization—by way of this innate wisdom, this global vision of the real and the just, this *grace* which marks his very core of being—than the majority of German professors or French essayists.

The continuity of culture can only be a function of its constant renewal. How strange that anyone would refuse to understand this, since renewal is a condition of life itself; since

the children of men can only perpetuate, or even conserve life, by adapting its forms and effusions to the evolution of the *milieux* which they are called upon to maintain or to transform. It is this bewildered center—the crowds, rising to the occasion of life, selected through invisible veils like this transformation, in the entrails, in flesh, in bone, in blood, in nervous tissue, of absorbed foods,—that we call "the people"; the masses, moving and fermenting, always in close contact with the desires, the disgusts, the humiliations, the hopes, and beneath it all, the working materials that link the hand to the brain: craft, tools, metals to forge and to burnish, land to cultivate, clay to bake, walls to construct, bread to knead, a living to earn. The myth of Antaeus is still fresh. The spirit can only be reborn in the body after having touched the soil. One gladly imagines that a writer, an artist, a creator of any kind is only adding a link to the culture that preceded him, and that this link is forged in peace, in security, in the calm of a social body where the elite strive to establish, for the needs of the father in the son, their hereditary empire. In reality, culture only represents the culmination of an ancient effort, as old as human and animal life, even as old as plant life. It does this through the internal linking of economical and biological forces, through a visceral and obscure circulation of hard work and enduring sacrifices, agreed to in anonymity, so that they may bloom one day in a few hearts, and bear fruit in a few minds. When this secular tension runs up against the revolutionary explosion of a grand social construction, it is *in this explosion* that tradition must be sought.

Above all, do not have us say what we do not mean. We know better than you that in the course of history there have existed long confused periods in which the masses have been mistaken, without doubt because they have been fooled, their fatigue put to rest by fairy tales, their pain and their boredom humored, their despair, vanity and nonchalance directed toward impasses into which they charge full speed, blinded by their artlessness.

These are, it seems to me, the intervals of history, the analytical periods where individualism reigns, the social waverings over the course of which, thanks to a discipline agreed upon by all, men lose sight of the interests of Man. And the end of the Hellenic world, the end of the Christian world, the end of the Islamic world, the end of the Buddhist world, demonstrate for us the spectacle of these tragic dispersions, wherein each isolated being, if he is to survive, is left only the recourses of pillage, slavery, or genius. It is exactly during these times, when "the masses" are prey to the kind of evil that has created individualism itself, that they are spoken of with disdain.

But you would not write what you write if you did not sense, as we do, that the masses, already made anarchists by the elite, are aware of their common reality because they have finally understood that everyone is faced with the choice between fatal dispersion and liberating cohesion. We are talking about the phenomenon of brusque crystallization, where all the living elements of Becoming reunite in the clear perspective of their closest and most crass interests. In these mo-

ments, the forms of moral hunger depend upon material appetite. In the hour in which I write, I predict that we will have the chance to encounter, in any man plucked at random from a crowd of communists or unionists, *more* real nobility, a greater spirit of sacrifice, and more spiritual *elan* than exist in all the economic, political, esthetic or religious circles which see themselves as guiding culture and humanity toward some superior destiny. This necessary, subterranean fire, which you seek out in Marxism, where in effect it would only know how to exist in force, or at a state of equivalence, is born and believed with the passion that carries the masses to pursue their social development, in the spirit of hope and of struggle. Do you believe that there was something else in Christ's first followers—in admitting that this marvelous story had not been invented after the fact, in the lyrical exaltations of a success which designed itself, do you believe that there was something other than the desire to know a little of justice and to taste a little happiness? The revolt in the face of injustice drives towards heroic humanity, especially in times like ours which could be termed mythic, where a speculative science recreates the poetry of the world by relentlessly pursuing the spiritual chain from the chromosome lost in the swamp bucket to human genius, while at the same moment grasping in space the universal and continuous movement which binds the dance of ions with the dance of suns. The new mystique will be born of the confluence of the myth which science extracts (unawares) from dynamic biology, and the people's struggle for bread and for liberty.

I know, you refuse to confuse "the people" with "the masses," and if you consent to recognize in the *people* the virtue of renewal—what I have in the past termed "the reserve of innocence of the space"—necessary to society, you do not accord it to the *masses*. I admit that I don't quite grasp the *distinction*. Would it be that you consider the masses as a material to be worked, not as an instrument of creation which is self-sufficient, especially when it is guided in its action by a constructive method, no longer having anything to do with abstract ratiocination and sentimental arguments? I don't know. There are still some subtleties that escape me. You tell us that "the masses" are the "leftovers, not the beginnings." Does one have the right to treat as "leftovers" the very base, the unlimited depth, upon which is erected the economic world and the world of hopes which superimposes itself on their needs? Isn't this no longer the sentiment of an upstart, but that of an aristocrat (as must be all sentiments whose roots plunge to the abyss of what is human)? Won't the "persons" (since you insist upon this word) rise from the underlying masses like the flower that pierces the tree, the tree that shoots up through the earth? This failure to recognize the masses, wouldn't this be precisely the characteristic not of your "personalism" but of the individualism that you repudiate as we do because of its refusal to plunge into the bath of blood, sweat and tears which is the only food for the spirit? How could a Christian refuse to recognize that Christianity itself, like Brahmanism or Buddhism, like ancient Paganism, is sprung from the unknown masses of carpenters, village

fishermen, prostitutes and village merchants, of dockers at the port, and of the immense bog of slaves, toward which the individualists prove to be so violently hostile, as today's individualist combats the profound movement of the collective? What *we* understand by "the masses" is the unaccountable, the diverse, the humble producers of the mind and of the hand.

Indeed, we would brush aside without great remorse the herd of intermediates, the immobile and routined "*petit-bourgeoisie*" who are the real leftovers, the grimy scum and the debris who spoil on the sand when the wave crashes back down, if we were sure that they are the ones that separate us from the communist Catholics, and above all if we didn't think that they provide the masses with some very useful reactions. For it is true that they have lost the instinct for having claimed to disengage themselves from the masses, and that they haven't found intelligence because their desire to persevere in their way of Being is conditioned by their laziness of Spirit.

"The person" will only emerge from a renewed organization whose power is in its belief, and whose logic is in the progressive development of its needs and its directions. To start with the person instead of starting with the group is equivalent—to you who customarily place creation and election at the beginning—to reaching death in order to know life according to your old formula, for your society, you know and admit it as we know and say it ourselves, makes less and less of "persons."

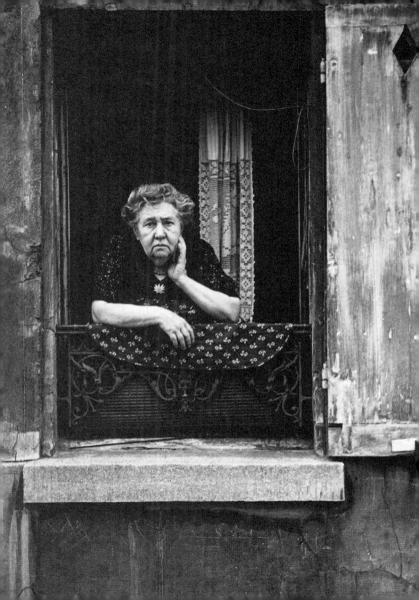

But unlike you we also think that the *person* can only emerge from the interior movements that cause the masses, in order to organize their aspirations, to seize the levers of command of this presently anarchistic society. Society will split if you expect to take advantage of a number of "persons" in order to construct the edifice, the plan for which I find a bit too subjective, even though the Marxist bricklayer has for a long time been on site. The founders of Christianity, our ancestors as well as yours, had objected to the blind obedience demanded by confessional conformity, and they were right to do so. Who could be made to believe, I ask you, that the carpenters and the fishermen of Galilee, the prostitutes of Alexandria, the merchants of Tyre, the dockers of Antioch, the rabble of Suburre already constituted "persons" as conscious and as defined as Thomas Aquinas? Blind need guided them. True leaders are born of combat, and do nothing but surround the troops whose hunger they share and whose spirits they enlighten. Marxism does not claim to create history. It is a critical and scientific confirmation of both the internal and external forces of Man, which guide it towards the destiny that you claim to know, but which Marxism, humbler than you, refrains from defining.

We must always begin with the beginning, the discovery of the world. Though you may have intelligence, what we have is the bloody and bitter depths of vital necessity. And you fall prey to the same mistake as the philosophers of the most extreme Hellenic culture, by imagining that it is possible to reconstruct the world with this overly content, would-be intelli-

gence (which, if it is examined for its constructive virtues, may not be on your side at all). You quote Tradition as your authority and study it from the outside, good Sophists that you are, while we proceed from within it, towards its permanent conquest. I have named Marcus Aurelius and Julian. They could not manage to drive back Christianity, being Christians without knowing it. Because you look upon unionism with sympathy and Communism without fright, the Catholic world will not be saved by you. The masses two thousand years ago got the better of the clerics trained in Ancient thought. The masses of today will get the better of the clerics trained in Christian thought. The fathers of our church are no more illuminated prophets than your own church fathers were. They are clairvoyant witnesses of what the masses demand, in order to create and maintain, for the longest time possible, a new equilibrium in the heart.

## III

What then does your "personalism" bring to this gestating equilibrium, if you first separate it from the great unanimous movements of instinct and need, necessary not only for its desirability, but for its creation? Certainly, I don't confuse any more than you do the very noble tendencies which you baptize "personalism" with the individualism that is killing Western society, having myself written a few years ago that the new man does not need to call himself an individualist—rather, he needs to *be* an individual. But, the true individual has only appeared in history as a force antithetical to anarchy among the

masses, or on the contrary as a force upholding the order the masses are required to construct from one time to another. To us, you sing the praises of solitude. We know it well, and we love it. We have always called upon it, passionately, to help us enter into ourselves. But we claim that it is to the heart of the orchestra that solitude lovingly offers the ripest, sweetest fruits of its contemplation, that these fruits may best be tasted by man. I fear that "personalism" puts the cart before the horse, follows your incurable dualism, and attempts to found an imperfect State upon a perfect individual; whereas we deem, on the contrary, the one as imperfect as the other, but hold that certain general measures meant to liberate the individual from the reign of dogma, of family, of property, and to guarantee his sustenance above all else, will set both the individual and the state on a path in the direction of a less imperfect order. I am suspicious of plants without roots. "The person makes his own fate" you tell us. No; the destiny of a person is made, for half the population by the underworld, for a quarter by atavism. And if you do not listen to the needs of the masses that envelop like an atmosphere, and determine to a large extent the quality of a person, I will defy you forever to cure atavism or to reform the underworld.

There is, elsewhere, an internal contradiction between your conception of liberty, upon which you rest the entirety of Christian philosophy, and your new system which *appears* to renounce dualism, when dualism is the origin and safeguard of your conception. For this system claims to place "the person," the image of liberty, standing in the threshold of a mo-

nistic universe—a universe from which any transport over the social terrain must take into account the actions of the masses and the underworld, and which seems to me to be in full antagonism with the idea which you hold to be of the essence and the very condition of freedom. Catholicism professes that Man is "born free," but that he refuses to consent to his own freedom. We believe, we monists and biologists, that man is not born free—and the quickest glance at the gravitation of the stars, the degree of coagulation of the albumin, and the weight of heredity, (or cradles ravaged by syphilis, alcohol, tuberculosis, and famine) suffice to demonstrate it—we believe that he is not born free but that he enjoys the privilege to triumph over his servitude, or at least to attenuate it. We believe that what you call "Spirit" imposes upon what you call "matter," by virtue of an incessant reversibility, of the elements of evolution and of revolution which it derives from matter itself. But we also know that if he modifies his *milieu* (which God leaves well enough alone), his chances are greatly improved of clearing these arduous paths.

You tell us that "the person introduces into the world a new dimension, Freedom," and in that we agree with you more than you agree with yourselves—you who admit to us candidly that before Man, there was no freedom, which is in our understanding the greatest, and doubtlessly the most unique, glory of Man. And perhaps we would understand one another if you hadn't elsewhere affirmed that Man is free and that he does not change, that this immobility of Man remains, by your own confession, one of the capital arguments of Catholic

thought, whereas we claim that the weapon of Freedom, which he must seize only when his circumstances cause him to need it confers upon him precisely the faculty to change. Thus we are separated from "the election" in the space of thought, as it separates itself from us in the obscurity of time. No, "the person" is not the only one responsible for his safety. It is society which retains the great part of this responsibility, since, at least eight times out of ten, society condemns man, by the sole fact of his birth, to the nearly impossible task of worrying about his own safety. And admit it, the church by maintaining in man the idea of eternal reward, was not the last to sign this condemnation.

It is strange that, in the social plan that you masterfully sketch of the future, you are wary of making the slightest allusion to a church which you defend. We think that a provisional understanding, but very pure and very profound, can exist between the people and Catholicism, and I admit that I know of nothing in history so noble as the protestations of some Catholic Spaniards against the massacres perpetuated by their armies and prepared by their Church, when Spanish people themselves tore away the swords from this army and the power from this Church. But I can only figure that those who have left Reason for Catholicism because they were lacking love, will one day be so disposed to leave Catholicism for Communism, because Catholicism lacks probity. And it is difficult for me to believe that this understanding between Catholicism and Communism could last if Catholicism does not

split off from the church, which would destroy it in an attempt to return it, by re-integrating it into the human domain, to the universality of its mission.

When it is a question of people, you see—and today you tend as we do to talk about people, in elevated terms—one always returns to Christ, the exaltation of the people and the negation of the Church. The insistence of the best among you to talk to us about Christ will perhaps finish well, by depossessing the clergy of their spiritual exploitation. Are you ready, Catholic Communists, to get rid of the priests? Pardon me for asking, but in your noble project of human and national renovation, I have searched in vain for the place of a caste living on the margins of the nation and the noble concerns of Man. And in the excellent counsels that you lavish upon the working class regarding the organization of collective works and the public fortune, I have searched in vain for a place the church might occupy. Will you stand against the State, which we find sympathetic, and end up when all is said and done by bestowing on the Church the spiritual dictatorship you refuse the State? If yes, better to say it, and we will understand each other better. For we don't want any more of the Church. Of course we remember the large role it has played in times before the existence of an organically or a scientifically based society, when its role was to counteract and to disallow military anarchy. But the Church stopped being useful to us the moment it realized that it would only last if it allied itself more or less overtly with this military anarchy, stylized by the monarchy and the unification of the great

States. Thanks to the overlapping disaffection of the people with regard to the profound, though puerile myths upon which it is established, and thanks as well to the economic evolution which little by little crystallizes the crowd of workers around a spirituality that has for the past two centuries been renewed by scientific thought, becoming more poetic each day—the Church has become an organization independent from human society, a foreign body to society's flesh and blood. From now on, all that can be saved of Christianity is what is already incorporated in our instinct.

The Church is responsible for a large part, if not for the largest part, of this division of humanity into two classes, which has been so bitterly demonstrated by Marxism, and which is recognized nonetheless by many Catholics, yourselves included. The Church has created the mystique of poverty, and the mystique of choice. To the poor it promised eternal life, then rejected them all in one blow, with the inertia of conscience against which Jesus tried to react, and which Paul's interpretation of his words recreated to serve as a new basis for Roman Imperialism. It has almost always implemented, if not approved of, the domination of the rich over the poor, of the master over the slave, of the owner over the employee, of the profiteer over the creator. Thanks to the material wealth of the conquerors of the earth, the Church could maintain in the poor the illusion of a Paradise, so necessary to the social equilibrium it has established. Why, in this despiritualization of the people organized by Capitalism, has the Church not played the role of defense and of redressment that

it should have played if its thought really conformed with the idea you have of its spiritual function? Can you affirm to us that by allying itself with Capitalism, the Church hasn't participated in this very despiritualization? Do you not find it strange that this patented guardian of the Spirit is credited with all the great moments of the Spirit, but isn't held accountable for its great failures? In a word, are you sure that the Church, or even Christianity, is the exclusive synonym of spirituality? "Man," you tell us, "is made in the image of God." *We* believe that God was made in the image of Man, and is nothing but a static image on the idealistic screen of a human dynamism that is in perpetual becoming. One of you said to me one day that "Catholicism has an answer for everything." And this is right, as long as a certain number of postulates such as "individual immortality" or "freedom" are admitted when the whole problem consists in getting rid of most of these postulates. While Catholicism has lasted this long, is it because the illusion that it promotes is only verifiable in death?

## IV

The fact that in your manifesto the Church is not questioned is enough to demonstrate the incurable dualism which you *claim* to renounce in this same manifesto, and which, in the profound depths of people's souls, is at least as responsible for the creation of social classes as the economic evolution out of which Capitalism sprang. If there is antagonism between matter and force, it is normal that there also be antagonism

between brutishness and Spirit, between those who obey and those who command, and (by a paradox which reverses your values), between those who create and those who consume, between the workers and the idlers who believe themselves to be the chosen. As for us, we no longer permit any equivocation over the word "matter." We are not more "materialist" than "spiritualist." We demand the right to use these words for the purposes of language, and according to the circumstances when we have to use them. We believe that "the spiritual" is the spark which ignites upon contact between intelligence and sensuality, inconceivable outside of the tangled and continuous associations between what you call "spirit" and what you call "matter." We regard them both as simple modes of an indivisible substance reacting against one another in this infinitely complex state of reciprocal reversibility which we have just described in our discussion of Freedom. We think that any mystery lies in the subconscious testimony of an incessantly *becoming* interior life, which reflects our biological evolution in its interdependent relationship to universal evolution, and which, in order to maintain our will to action and our lyrical drunkenness, never manages completely to fix its own future in definitive ideas and exact images. That is where the mystery is for us, and not elsewhere. If you try to situate it outside of ourselves, you cut the world in half.

You rally around monism illegitimately, and by way of oblique roads. You forget this troubled adherence throughout your argumentation. You see, everywhere and always, what we have ceased to see ourselves—movements without form,

and forms without movement. You demonstrate with excellence what we have known and affirmed for many years, that medieval Christianity, the highest point in so-called Christian civilization, was Monist; but risking its being smashed you furtively steal from below it the pedestal upon which it has constructed the form of Christianity. For it seemed that if the Middle Ages were Monist, they couldn't be specifically Christian, because they have thus placed themselves in a position that is clearly antagonistic to that of Christianity. For Dualism, no matter what you say, does not date to Descartes (who until very recently you claimed as your own), but derives via a straight line from the Hellenistic roots of your Confessions, and, more legitimately, from St. Paul. If you wish to free yourselves of Dualism, you must free yourselves of St. Paul, and renounce God Himself, since Monism, in order to live, must renounce the antimony between creation and the Creator. The holy Trinity, certainly Monist in appearance, offers a profound sense of mystery. I recognize in it, with emotion, an expected and perfectly acceptable symbol of a Monism that is reestablished for our times by Science, with its own spiritual dignity. In this bold view of Greco-Alexandrian philosophy intuition of the real anticipates the more or less close apparition, and prepares the terrain for the builders and the image makers. A flagrant refutation of Paulinism and a weak response to the *essential* antimony must exist on metaphysical and moral ground as well as on scientific ground, between a first conscience anterior to and independent of "matter," and matter itself, created by conscience and deprived of the power

to act upon it, or to modify its direction and nature. I find that this Monism, as heroic as the intellectual tentative it represents, must be constrained in order to maintain itself with all the consequences in human dynamism, to no longer see in "our father" any more than a symbolic but unconscious expression of universal movement. The "holy spirit" does not descend into "the son" who is Man. On the contrary, it is to Man and Man only that it climbs, in order to endow universal movement with human conscience, while at the same time introducing into it the freedom to direct the mechanism towards the best of Man's greatness.

Do you still believe in the existence of two worlds, that of the earth during life, and that of Heaven after death? If so, give us an explanation of this assertion that is scientific, and not mythic. If not, then hold on to the mythic explanation, and wholeheartedly rejoin the simpletons in their beliefs that you have assigned them. You tell us that Marxism denies "the spiritual as an autonomous, primary and creative reality." If you are truly Monist, why reproach it for that?

I tell you this truthfully. You will not take hold of Monism as you have tried in turn to take hold of reason and science, and I realize that it took a transcendental *tour de force* to maneuver through these reefs, which each time you thought you had cleared, but which so closely defend the continent which we are conquering, that you can only penetrate us by abandoning to its maze the broken ship of the Church. Our door is open wide to the great Catholics who align themselves, against their Princes, next to the poor people, but on the con-

dition that they don't hold open the door to let the Church in behind them.

You attribute to Catholicism the renaissance of an interior life, which actually seems to be trembling everywhere at the surface of conscience. We think that this episode in its history—in its long history—expresses, especially now, the anger and the terror of the possessors, the irresolute, and the weak before the great unknown; we think that this renaissance is a sign of the spirit and activity that result on all fronts from this terror and this anger. We do not need Catholicism in order to seize control of ourselves. The profound and continuous movement which, before our eyes, is replacing the reign of ideas of authority, power and well-being with the reign of the ideas of sickness, renunciation, and the humility demanded by the church in order to more easily inflict their domination of this temporal world, we consider a necessity, both economical and biological, whose consequences we accept. For we do not want the poor to be, as they have been for some two thousand years, victims of this grandiose reversal of values, which seems to be the periodic law of history, like the changing rhythm of footsteps on the path trailing behind a weary traveler. They are the ones who shall *become* the authority, power and well-being that we will regard from here on out as the most steadfast teachers of generosity, liberty and justice. If only *they* can perceive it thus, the world might be saved.

# RESURRECTION
# OF A LIFE

## WILLIAM SAROYAN

Everything begins with inhale and exhale, and never ends, moment after moment, yourself inhaling, and exhaling, seeing, hearing, smelling, touching, tasting, moving, sleeping, waking, day after day and year after year, until it is now, this moment, the moment of *your* being, the last moment, which is saddest and most glorious. It is because we remember, and I remember having lived among dead moments, now deathless because of my remembrance, among people now dead, having been a part of the flux which is now only a remembrance, of myself and this earth, a street I was crossing and the people I saw walking in the opposite direction, automobiles going away from me. Saxons, Dorts, Maxwells, and the streetcars and trains, the horses and wagons, and myself, a small boy, crossing a street, alive somehow, going somewhere.

First he sold newspapers. It was because he wanted to do

---

``It was about this time that Bill Saroyan began to write me letters from San Francisco. He was just going through a resurrection, having taken a taxi to laughter and unending life.''

53

something, standing in the city, shouting about what was happening in the world. He used to shout so loud, and he used to need to shout so much, that he would forget he was supposed to be selling papers; he would get the idea that he was only supposed to shout, to make people understand what was going on. He used to go through the city like an alley cat, prowling all over the place, into saloons, upstairs into whore houses, into gambling joints, to see: their faces, the faces of those who were alive with him on the earth, and the expressions of their faces, and their forms, the faces of old whores, and the way they talked, and the smell of all the ugly places, and the drabness of all the old and rotting buildings, all of it, of his time and his life, a part of him. He prowled through the city, seeing and smelling, talking, shouting about the big news, inhaling and exhaling, blood moving to the rhythm of the sea, coming and going, to the shore of self and back again to selflessness, inhale and newness, exhale and new death, and the boy in the city, walking through it like an alley cat, shouting headlines.

The city was ugly, but his being there was splendid and not an ugliness. His hands would be black with the filth of the city and his face would be black with it, but it was splendid to be alive and walking, of the events of the earth, from day to day, new headlines every day, new things happening.

In the summer it would be very hot and his body would thirst for the sweet fluids of melons, and he would long for the shade of thick leaves and the coolness of a quiet stream, but always he would be in the city, shouting. It was his place and he

was the guy, and he wanted the city to be the way it was, if that was the way. He would figure it out somehow. He used to stare at rich people sitting at tables in hightone restaurants eating dishes of ice cream, electric fans making breezes for them, and he used to watch them ignoring the city, not going out to it and being of it, and it used to make him mad. Pigs, he used to say, having everything you want, having everything. What do you know of this place? What do you know of me, seeing this place with a clean eye, any of you? And he used to go, in the summer, to the Crystal Bar, and there he would study the fat man who slept in a chair all summer, a mountain of some- body, a man with a face and substance that lived, who slept all day every summer day, dreaming what? This fat man, three hundred pounds? What did he dream, sitting in the saloon, in the corner, not playing poker or pinochle like the other men, only sleeping and sometimes brushing the flies from his fat face? What was there for him to dream, anyway, with a body like that, and what was there hidden beneath the fat of that body, what grace or gracelessness? He used to go into the sa- loon and spit on the floor as the men did and watch the fat man sleeping, trying to figure it out. Him alive, too? he used to ask. That great big sleeping thing alive? Like myself?

In the winter he wouldn't see the fat man. It would be only in the summer. The fat man was like the hot sun, very near everything, of everything, sleeping, flies on his big nose. In the winter it would be cold and there would be much rain. The rain would fall over him and his clothes would be wet, but he would never get out of the rain, and he would go on prowling

around in the city, looking for whatever it was that was there and that nobody else was trying to see, and he would go in and out of all the ugly places to see how it was with the faces of the people when it rained, how the rain changed the expressions of their faces. His body would be wet with the rain, but he would go from one place to another, shouting headlines, telling the city about the things that were going on in the world.

I was this boy and he is dead now, but he will be prowling through the city when my body no longer makes a shadow upon the pavement, and if it is not this boy it will be another, myself again, another boy alive on earth, seeking the essential truth of the scene, seeking the static and precise beneath that which is in motion and which is imprecise.

The theatre stood in the city like another universe, and he entered its darkness, seeking there in the falsity of pictures of man in motion the truth of his own city, and of himself, and the truth of all living. He saw their eyes: *While London Sleeps*. He saw the thin emaciated hand of theft twitching toward crime: *Jean Valjean*. And he saw the lecherous eyes of lust violating virginity. In the darkness the false universe unfolded itself before him and he saw the phantoms of man going and coming, making quiet horrifying shadows: *The Cabinet of Dr. Caligari*. He saw the endless sea, smashing against rocks, birds flying, the great prairie and herds of horses, New York and greater mobs of men, monstrous trains, rolling ships, men marching to war, and a line of infantry charging another line of infantry: *The Birth of a Nation*. And sitting in the se-

crecy of the theatre he entered the houses of the rich, saw them, the male and the female, the high ceilings, the huge marble pillars, the fancy furniture, great bathrooms, tables loaded with food, rich people laughing and eating and drinking, and then secrecy again and a male seeking a female, and himself watching carefully to understand, one pursuing and the other fleeing, and he felt the lust of man mounting in him, desire for the loveliest of them, the universal lady of the firm white shoulders and the thick round thighs, desire for her, he himself, ten years old, in the darkness.

He is dead and deathless, staring at the magnification of the kiss, straining at the mad embrace of male and female, walking alone from the theatre, insane with the passion to live. And at school their shallowness was too much. Don't try to teach me, he said. Teach the idiots. Don't try to tell me anything. I am getting it direct, straight from the pit, the ugliness with the loveliness. Two times two is many millions all over the earth, lonely and shivering, groaning one at a time, trying to figure it out. Don't try to teach me. I'll figure it out for myself.

Daniel Boone? he said. Don't tell me. I knew him. Walking through Kentucky. He killed a bear. Lincoln? A big fellow walking alone, looking at things as if he pitied them, a face like the face of man. The whole countryside full of dead men, men he loved, and he himself alive. Don't ask me to memorize his speech. I know all about it, the way he stood, the way the words came from his being.

He used to get up before daybreak and walk to the San Joa-

quin Baking Company. It was good, the smell of freshly baked bread, and it was good to see the machine wrapping the loaves in wax paper. *Chicken bread*, he used to say, and the important man in the fine suit of clothes used to smile at him. The important man used to say, What kind of chickens you got at your house, kid? And the man would smile nicely so that there would be no insult, and he would never have to tell the man that he himself and his brother and sisters were eating the chicken bread. He would just stand by the bin, not saying anything, not asking for the best loaves, and the important man would understand, and he would pick out the best of the loaves and drop them into the sack the boy held open. If the man happened to drop a bad loaf into the sack the boy would say nothing, and a moment later the man would pick out the bad loaf and throw it back into the bin. Those chickens, he would say, they might not like that loaf. And the boy would say nothing. He would just smile. It was good bread, not too stale and sometimes very fresh, sometimes still warm, only it was bread that had fallen from the wrapping machine and couldn't be sold to rich people. It was made of the same dough, in the same ovens, only after the loaves fell they were called chicken bread and a whole sackful cost only a quarter. The important man never insulted. Maybe he himself had known hunger once; maybe as a boy he had known how it felt to be hungry for bread. He was very funny, always asking about the chickens. He knew there were no chickens, and he always picked out the best loaves.

Bread to eat, so that he could move through the city and

shout. Bread to make him solid, to nourish his anger, to fill his substance with vigor that shouted at the earth. Bread to carry him to death and back again to life, inhaling, exhaling, keeping the flame within him alive. Chicken bread, he used to say, not feeling ashamed. We eat it. Sure, sure. It isn't good enough for the rich. There are many at our house. We eat every bit of it, all the crumbs. We do not mind a little dirt on the crust. We put all of it inside. A sack of chicken bread. We know we're poor. When the wind comes up our house shakes, but we don't tremble. We can eat the bread that isn't good enough for the rich. Throw in the loaves. It is too good for chickens. It is our life. Sure we eat it. We're not ashamed. We're living on the money we earn selling newspapers. The roof of our house leaks and we catch the water in pans, but we are all there, all of us alive, and the floor of our house sags when we walk over it, and it is full of crickets and spiders and mice, but we are in the house, living there. We eat this bread that isn't quite good enough for the rich, this bread that you call chicken bread.

Walking, this boy vanished, and now it is myself, another, no longer the boy, and the moment is now this moment, of my remembrance. The fig tree he loved: of all graceful things it was the most graceful, and in the winter it stood leafless, dancing, sculptural whiteness dancing. In the spring the new leaves appeared on the fig tree and the hard green figs. The sun came closer and closer and the heat grew, and he climbed the tree, eating the soft fat figs, the flowering of the lovely white woman, his lips kissing.

But always he returned to the city, back again to the place of

man, the street, the structure, the door and window, the hall, the roof and floor, back again to the corners of dark secrecy, where they were dribbling out their lives, back again to the movement of mobs, to beds and chairs and stoves, away from the tree, away from the meadow and the brook. The tree was of the other earth, the older and lovelier earth, solid and quiet and of godly grace, of earth and water and of sky and of the time that was before, ancient places, quietly in the sun, Rome and Athens, Cairo, the white fig tree dancing. He talked to the tree, his mouth clenched, pulling himself over its smooth limbs, to be of you, he said, to be of your time, to be there, in the old world, and to be here as well, to eat your fruit, to feel your strength, to move with you as you dance, myself, alone in the world, with you only, my tree, that in myself which is of thee.

Dead, dead, the tree and the boy, yet everlastingly alive, the white tree moving slowly in dance, and the boy talking to it in unspoken, unspeakable language; you, loveliness of the earth, the street waits for me, the moment of my time calls me back, and there he was suddenly, running through the streets, shouting that ten thousand Huns had been destroyed. Huns? He asked. What do you mean, Huns? They are men, aren't they? Call me, then, a Hun. Call me a name, if they are to have a name dying. And he saw the people of the city smiling and talking with pleasure about the good news. He himself appreciated the goodness of the news because it helped him sell his papers, but after the shouting was over and he was himself again, he used to think of ten thousand men smashed from

life to violent death, one man at a time, each man himself as he, the boy, was himself, bleeding, praying, screaming, weeping, remembering life as dying men remember it, wanting it, gasping for breath, to go on inhaling and exhaling, living and dying, but always living somehow, stunned, horrified, ten thousand faces suddenly amazed at the monstrousness of the war, the beastliness of man, who could be so godly.

There were no words with which to articulate his rage. All that he could do was shout, but even now I cannot see the war as the historians see it. Succeeding moments have carried the germ of myself to this face and form, the one of this moment, now, my being in this small room, alone, as always, remembering the boy, resurrecting him, and I cannot see the war as the historians see it. Those clever fellows study all the facts and they see the war as a large thing, one of the biggest events in the legend of man, something general, involving multitudes. I see it as a large thing too, only I break it into small units of one man at a time, and I see it as a large and monstrous thing for each man involved. I see the war as death in one form or another for men dressed as soldiers, and all the men who survived the war, including myself, I see as men who died with their brothers, dressed as soldiers.

There is no such thing as a soldier. I see death as a private event, the destruction of the universe in the brain and in the senses of one man, and I cannot see any man's death as a contributing factor in the success or failure of a military campaign. The boy had to shout what had happened. Whatever happened, he had to shout it, making the city know. *Ten thou-*

*sand Huns killed, ten thousand*, one at a time, one, two, three, four, inestimably many, ten thousand, alive, and then dead, killed, shot, mangled, ten thousand Huns, ten thousand men. I blame the historians for the distortion. I remember the coming of the gas mask to the face of man, the proper grimace of the horror of the nightmare we were performing, artfully expressing the monstrousness of the inward face of man. To the boy who is dead the war was the international epilepsy which brought about the systematic destruction of one man at a time until millions of men were destroyed.

There he is suddenly in the street, running, and it is 1917, shouting the most recent crime of man, extra, extra, ten thousand Huns killed, himself alive, inhaling, exhaling, *ten thousand, ten thousand*, all the ugly buildings solid, all the streets solid, the city unmoved by the crime, *ten thousand*, windows opening, doors opening, and the people of the city smiling about it, good, ten thousand of them killed, good. *Johnny, get your gun, get your gun, Johnny get your gun: we'll be over, we're coming over, and we won't come back till it's over, over there*, and another trainload of boys in uniforms, going to the war. And the fat man, sleeping in a corner of the Crystal Bar, what of him? Sleeping there, somehow alive in spite of the lewd death in him, but never budging. Pig, he said, ten thousand Huns killed, ten thousand men with solid bodies mangled to death. Does it mean nothing to you? Does it not disturb your fat dream? Boys with loves, men with wives and children. What have you, sleeping? They are all dead, all of

them dead. Do you think you are alive? Do you dream you are alive? The fly on your nose is more alive than you.

Sunday would come, *O day of rest and gladness, O day of joy and light, O balm of care and sadness, Most beautiful, most bright*, and he would put on his best shirt and his best trousers, and he would try to comb his hair down, to be neat and clean, meeting God, and he would go to the small church and sit in the shadow of religion: in the beginning, the boy David felling the giant Goliath, beautiful Rebecca, mad Saul, Daniel among lions, Jesus talking quietly to the men, and in the boat shouting at them because they feared, angry at them because they had fear, calm yourselves, boys, calm yourselves, let the storm rage, let the boat sink, do you fear going to God? Ah, that was lovely, that love of death was lovely, Jesus loving it: calm yourselves, boys, God damn you, calm yourselves, why are you afraid? *Still, still with thee, when purple morning breaketh, abide, abide, with me, fast falls the eventide*, ah, lovely. He sat in the basement of the church, among his fellows, singing at the top of his voice. I do not believe, he said. I cannot believe. There cannot be a God. But it is lovely, lovely, these songs we sing, *Saviour, breathe an evening blessing, sun of my soul, begin, my tongue, some heavenly theme, begin, my tongue, begin, begin*. Lovely, lovely, but I cannot believe. The poor and the rich, those who deserve life and those who deserve death, and the ugliness everywhere. Where is God? Big ships sinking at sea, submarines, men in the water, cannon booming, machine guns, men dying, ten thousand,

where? But our singing, *Joy to the world, the Lord is come. Let earth receive her King. Silent night, holy night. What grace, O Lord, my dear redeemer. Ride on, ride on, in majesty. Angels, roll the rock away; death, yield up thy mighty prey.*

No, he could not believe. He had seen for himself. It was there, in the city, all the godlessness, the eyes of the whores, the men at cards, the sleeping fat man, and the mad headlines, it was all there, unbelief, ungodliness, everywhere, all the world forgetting. How could he believe? But the music, so good and clean, so much of the best in man: *lift up, lift up your voices now. Lo, he comes with clouds descending once for favored sinners slain. Arise, my soul, arise, shake off thy guilty fears, O for a thousand tongues to sing. Like a river glorious, holy Bible, book divine, precious treasure, thou art mine.* And spat, right on the floor of the Crystal Bar. And into Madam Juliet's Rooms, over the Rex Drug Store, the men buttoning their clothes, ten thousand Huns killed, madam. *Break thou the bread of life, dear Lord, to me, as thou didst break the loaves, beside the sea.* And spat, on the floor, hearing the fat man snoring. Another ship sunk. The Marne. Ypres. Russia. Poland. Spat. *Art thou weary, art thou languid, art thou sore distressed?* Zeppelin over Paris. The fat man sleeping. *Haste, traveler, haste, the night comes on.* Spat. *The storm is gathering in the west.* Cannon. Hutt! two three, four! Hutt! two three, four, how many men marching, how many? Onward, onward, unChristian soldiers. *I was a wandering sheep.* Spat. *I did not love my home.* Your deal, Jim. Spat. *Take me, O my father, take me.* Spat. *This holy bread, this holy wine. My*

*God, is any hour so sweet?* Submarine plunging. Spat. *Take my life and let it be consecrated, Lord, to thee.* Spat.

He sat in the basement of the little church, deep in the shadow of faith, and of no faith: I cannot believe: where is the God of whom they speak, where? *Your harps, ye trembling saints, down from the willows take.* Where? Cannon. *Lead, oh lead, lead kindly light, amid the encircling gloom.* Spat. *Jesus, Saviour, pilot me.* Airplane: spat: smash. *Guide me, O thou great Jehovah. Bread of heaven, feed me till I want no more.* The universal lady of the dark theatre: thy lips, beloved, thy shoulders and thighs, thy sea-surging blood. The tree, black figs in sunlight. Spat. *Rock of ages, cleft for me, let me hide myself in thee.* Spat. *Let the water and the blood, from thy riven side which flowed, be of sin the double cure.* Lady, your arm, your arm: spat. The mountain of flesh sleeping through the summer. Ten thousand Huns killed.

Sunday would come, turning him from the outward world to the inward, to the secrecy of the past, endless as the future, back to Jesus, to God; *when the weary, seeking rest, to thy goodness flee*; back to the earliest quiet: *He leadeth me, O blessed thought.* But he did not believe. He could not believe. Jesus was a remarkable fellow: you couldn't figure him out. He had a pious love of death. An heroic fellow. And as for God. Well, he could not believe.

But the songs he loved and he sang them with all his might: *hold thou my hand, O blessed nothingness, I walk with thee. Awake, my soul, stretch every nerve, and press with vigor on. Work, for the night is coming, work, for the day is done.* Spat.

Right on the floor of the Crystal Bar. It is Sunday again: O blessed nothingness, we worship thee. Spat. And suddenly the sleeping fat man sneezes. Hallelujah. Amen. Spat. Sleep on, beloved, sleep, and take thy rest. *Lay down thy head upon thy Saviour's breast.* We love thee well, but Jesus loves thee best. Jesus loves thee. For the Bible tells you so. Amen. The fat man sneezes. He could not believe and he could not disbelieve. Sense? There was none. But glory? There was an abundance of it. Everywhere. Madly everywhere. Those crazy birds vomiting song. Those vast trees, solid and quiet. And clouds. And sun. And night. And day. *It is not death to die*, he sang: *to leave this weary road, to be at home with God.* God? The same. Nothingness. Nowhere. Everywhere. The crazy glory, everywhere: Madam Juliet's Rooms, all modern conveniences, including beds. Spat. *I know not, O I know not, what joys await us there.* Where? Heaven? No. Madam Juliet's. In the church, the house of God, the boy singing, remembering the city's lust.

Boom: Sunday morning: and the war still booming: after the singing he would go to the newspaper office and get his SPECIAL SUNDAY EXTRAS and run through the city with them, his hair combed for God, and he would shout the news: amen, *I gave my life for Jesus.* Oh, yeah? Ten thousand Huns killed, and I am the guy, inhaling, exhaling, running through the town, I, myself, seeing, hearing, touching, shouting, smelling, singing, wanting, I, the guy, the latest of the whole lot, alive by the grace of God: ten thousand, two times ten million, by the grace of God dead, by His grace smashed,

amen, extra, extra: five cents a copy, extra, ten thousand killed.

I was this boy who is now lost and buried in the succeeding forms of myself, and I am now of this last moment, of this small room, and the night hush, time going, time coming, breathing, this last moment, inhale, exhale, the boy dead and alive. All that I have learned is that we breathe, and remember, and we see the boy moving through a city that has become lost, among people who have become dead, alive among dead moments, crossing a street, the scene thus, or standing by the bread bin in the bakery, a sack of chicken bread please so that we can live and shout about it, and it begins nowhere and it ends nowhere, and all that I know is that we are somehow alive, all of us in the light, making shadows, the sun overhead, space all around us, inhaling, exhaling, the face and form of man everywhere, pleasure and pain, sanity and madness, war and no war, and peace and no peace, the earth solid and un- aware of us, unaware of our cities, our dreams, the earth ever- lastingly itself, and the sea sullen with movement like my breathing, waves coming and going, and all that I know is that I am alive and glad to be, glad to be of this ugliness and this glory, somehow glad that I can remember the boy climbing the fig tree, unpraying but religious with joy, somehow of the earth, of the time of earth, somehow everlastingly of life, nothingness, blessed or unblessed, somehow deathless, in- sanely glad to be here, and so it is true, there is no death, somehow there is no death, and can never be.